HOW TO DRAW
DOGS, CATS
& HORSES

ARTHUR ZAIDENBERG

DOVER PUBLICATIONS, INC.
MINEOLA, NEW YORK

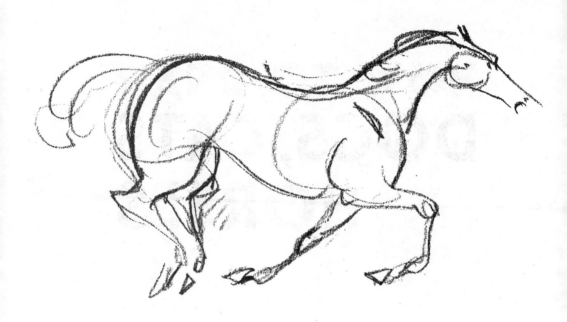

Bibliographical Note

This Dover edition, first published in 2014, is an unabridged republication of
the work originally published by Abelard-Schuman, New York, in 1959.

Library of Congress Cataloging-in-Publication Data

Zaidenberg, Arthur, 1908–1990.
 How to draw dogs, cats and horses / Arthur Zaidenberg.
 p. cm.
 "This Dover edition, first published in 2014, is an unabridged republication
of the work originally published by Abelard-Schuman, New York, in 1959."
 ISBN-13: 978-0-486-78048-1
 ISBN-10: 0-486-78048-1
 1. Dogs in art. 2. Cats in art. 3. Horses in art. 4. Drawing—Technique.
I. Title.

NC780.Z317 2014
743.6'9—dc23

2013045407

Manufactured in the United States by Courier Corporation
78048101 2014
www.doverpublications.com

CONTENTS

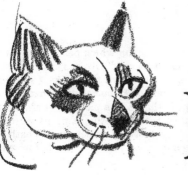

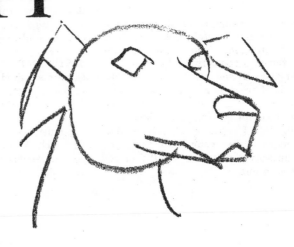

BASIC DRAWING MATERIALS

PENCILS

You are at home with the pencil. From your kindergarten days it has been your daily companion and has almost become a part of your hand — like another finger that writes and draws.

Why struggle with a strange tool if you know and understand the pencil so well? Get several pencils of different lead thicknesses so that you may make lines that are heavy and black or thin and light, as you wish. Keep them sharp with your pencil sharpener. There is no special way to hold a pencil for drawing. Any position that you are used to and find comfortable is the right one for *you* to use.

ERASERS

It is best to avoid erasing, as much as possible. If you keep your first *sketch* lines very light you can make the ones you decide to keep darker, and the ones you want to lose will then almost disappear. If you must erase get two different kinds of erasers: a *soap eraser*, which is the soft, crumbly kind, and a *kneaded eraser*, which is very good for erasing pencil lines without smudging. But, I repeat, don't rely on your eraser too much. Draw your lines as if you didn't own an eraser, and soon you'll find you don't really need one.

PAPERS

Almost any paper upon which pencil lines show is good "drawing paper." Ordinary white typewriter paper or your own notebooks (unlined) will be good enough for most drawings. What is important is that it be a pleasant surface and that you have a wad of the same paper or a heavy sheet of blotting paper underneath so that the surface is not too hard for easy drawing.

CRAYONS

If you like to work with crayons, make your first outlines in pencil or with a very sharp pointed crayon so that your drawing is not too rough and fuzzy as many crayon drawings are.

PEN AND INK

Only if you are used to working neatly with a pen should you use it for sketching. However, if you can control a pen and feel at home with it, it is a beautiful tool for drawing. Art supply stores now sell india ink fountain pens quite cheaply and they are very good.

SKETCH PAD

Get a good thick sketch pad small enough to fit in your pocket. Take it everywhere with you and draw every animal you see or, for that matter, anything else you see that appeals to you. Drawing must become a habit if you want to do it very well. A filled sketch book is a fine record of your experiences and a great way to develop your skill.

Introduction

The closest animal friends that man has are dogs, cats and horses. To be able to draw your pets is a great pleasure, and the process of learning how to draw them is not really difficult.

There are a few basic steps to be followed in constructing the forms of these animals, and these will be shown here. But — and this is of great importance — you must first learn to *know* these three beautiful animals. You must perceive their nature: the alert playfulness of the dog, the sly grace of the cat, and the strength and beauty of the horse. You must watch them in repose and in action and actually learn to think a little like they do.

A dog walks, stands, runs and plays in his own special manner because that is his dog-like character. A cat slinks and leaps and plays in certain ways which are part of his cat-like nature. And the quiet dignity of the horse shows his special way of life. These are things you must put into your drawings. Only when you can show these traits in your drawings will you be making *good* drawings of dogs, cats and horses.

Dogs and cats are all about you, ready for your study. Horses are worth seeking out, in the country or in city parks. If they are not to be found near your home, they certainly abound on your television screen.

Make sketches of them from life if possible. If you find

5

this difficult because they move about too much, watch them closely. Study their movements and the way they stand. Impress these movements and mannerisms on your mind, and they will appear in your drawings.

In this book you will follow the general shapes which build your animals. Add your feelings about them to what you learn here, and you will make beautiful drawings of dogs, cats, and horses that seem really alive.

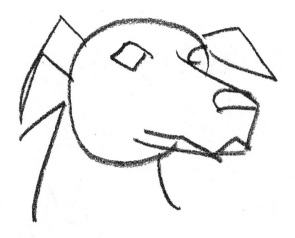

D O G S

No other animal has within its family as many different breeds as the dog.

There are fat dogs with crooked legs, thin dogs with long legs, blunt-nosed dogs, pointed-nosed dogs, flop-eared and sharp upright-eared dogs, long-haired and short-haired dogs. There are dogs with long whip-like tails and dogs with tiny powder-puff tails. There are ferocious dogs and timid dogs, lap dogs and fierce hunters.

Every shape, size, shade and character, is to be found among dogs.

But — and this is why you can learn to draw them all — the general, basic structure is the same in all dogs.

Learn to draw these basic shapes and forms, and you will be able to add all the surface differences easily.

This is the framework on which you can build your dog.

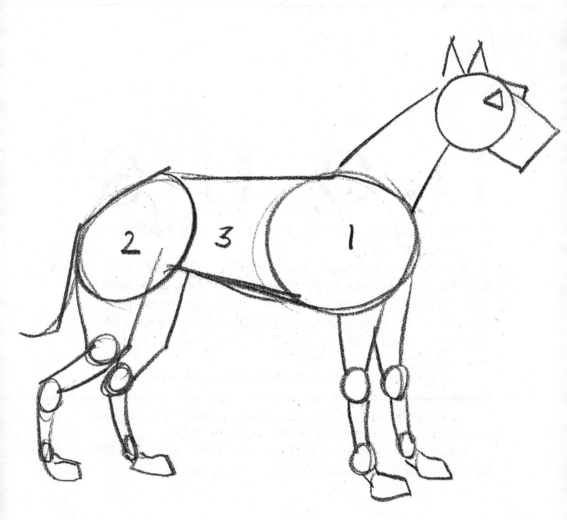

Notice how few details have been added
to make a finished drawing of a dog.

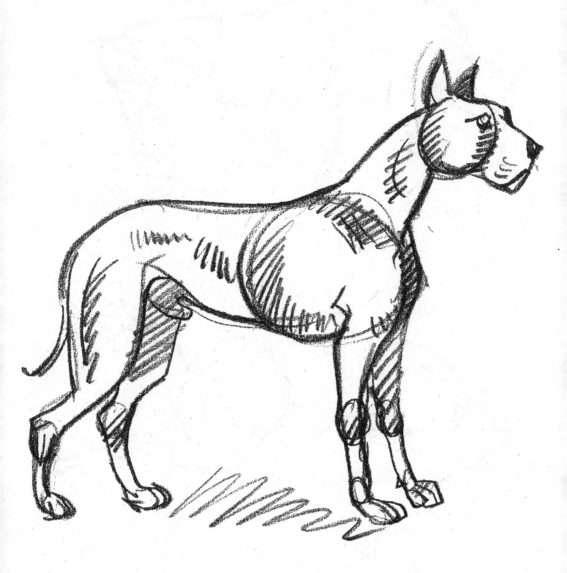

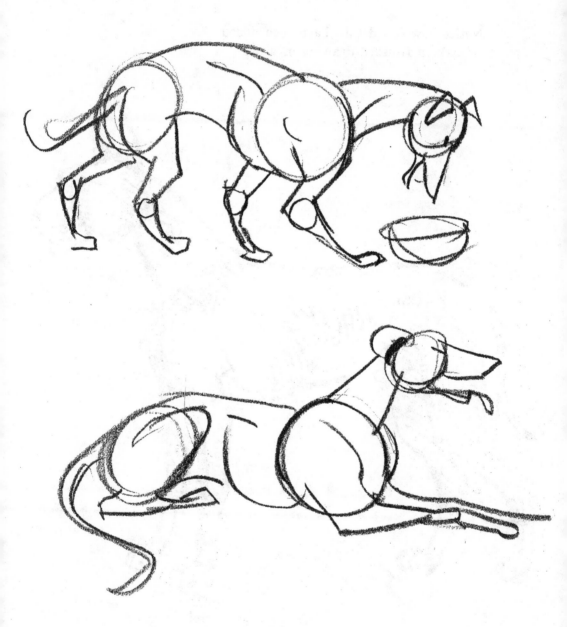

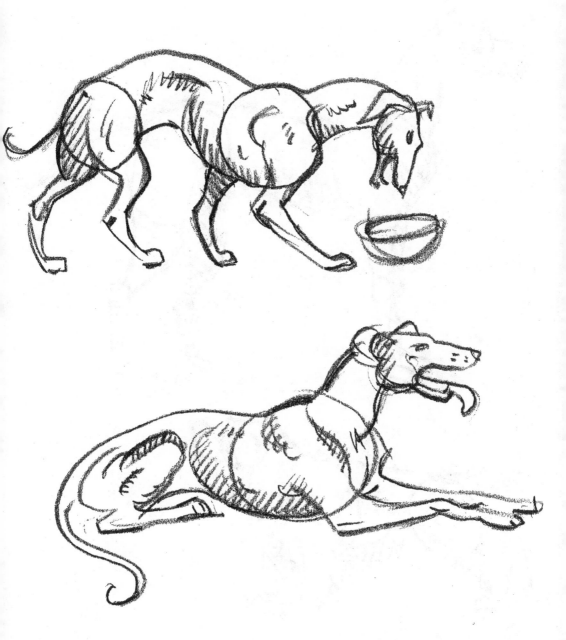

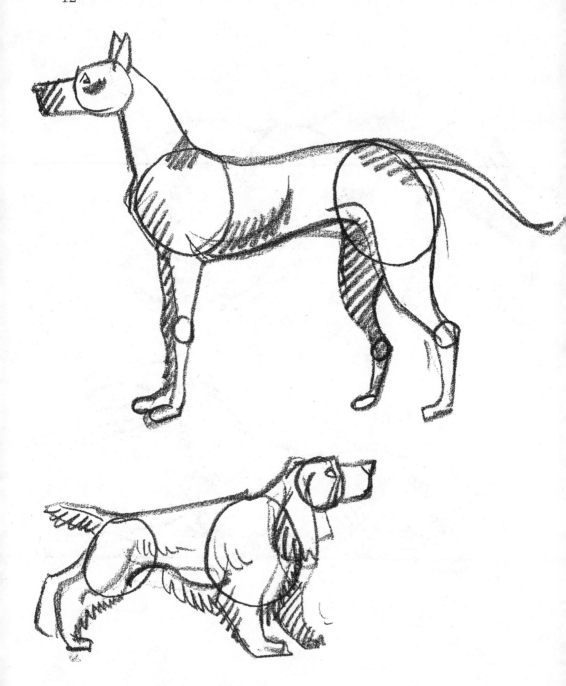

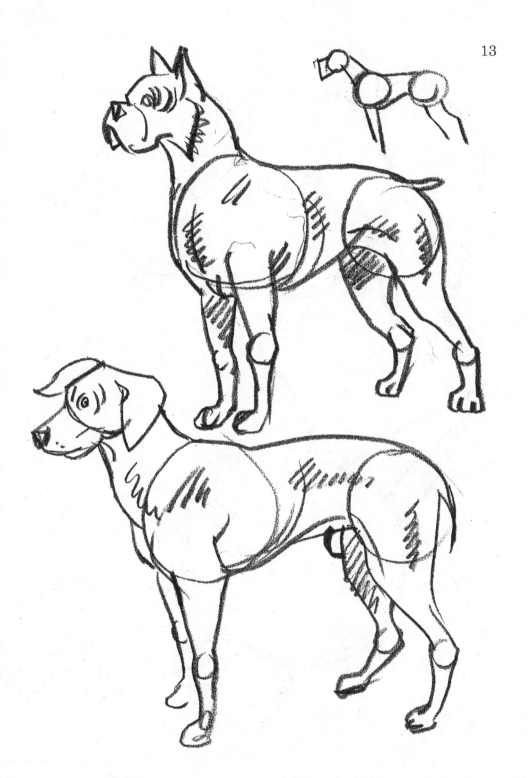

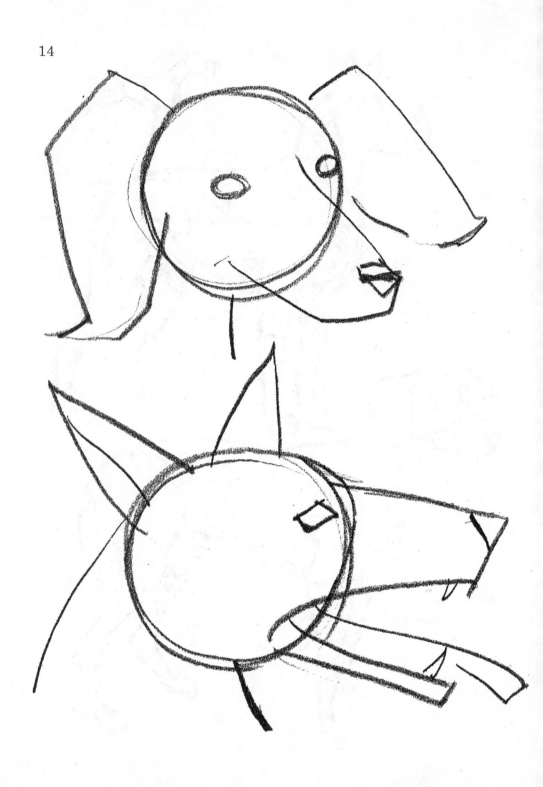

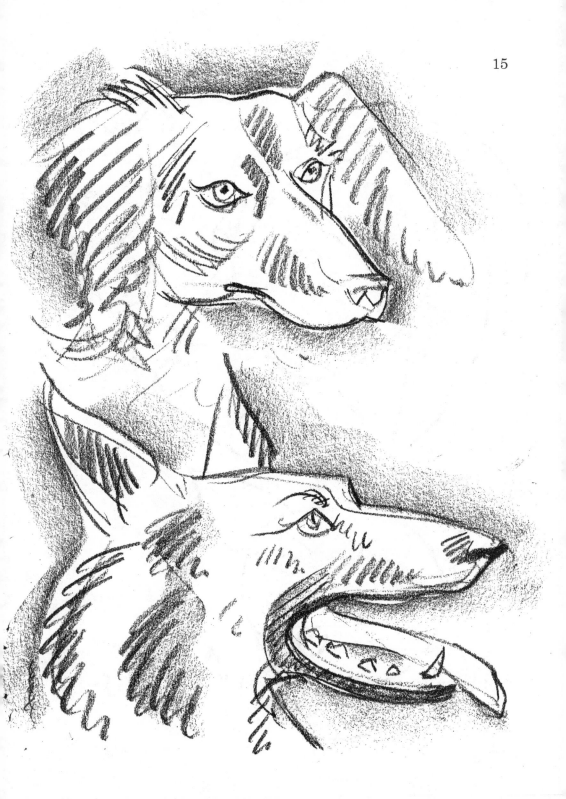

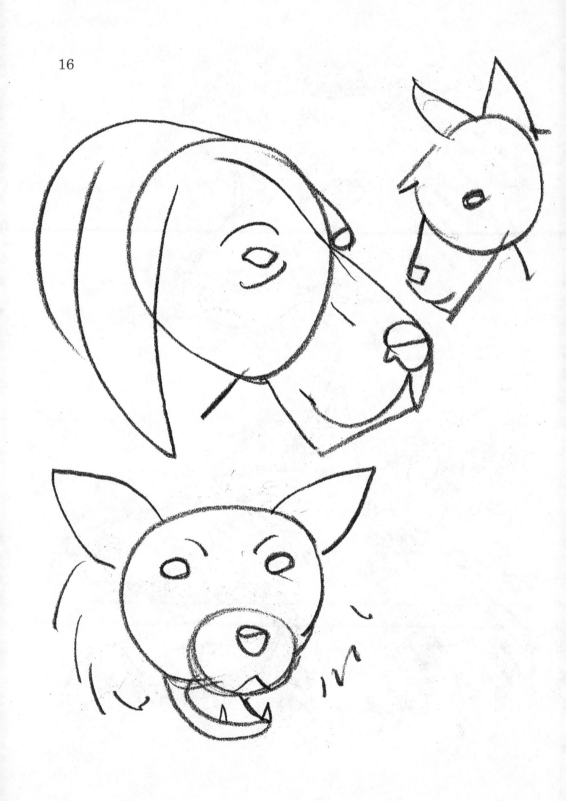

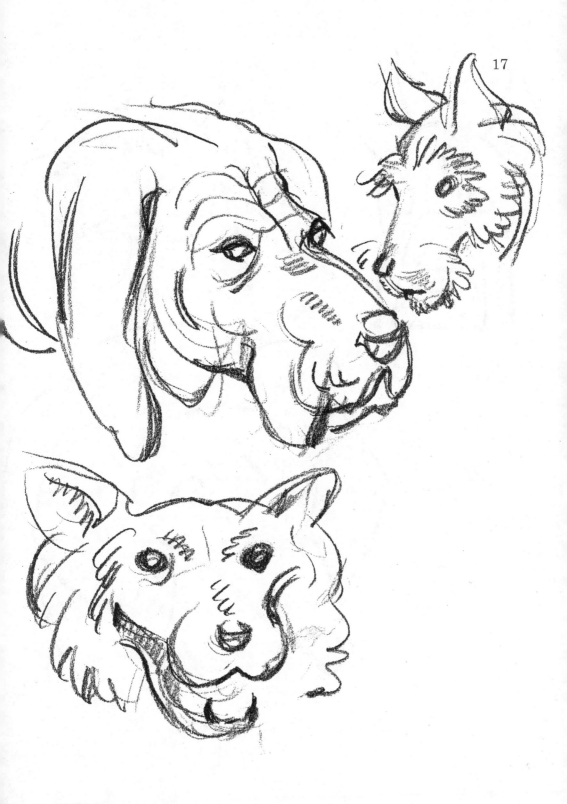

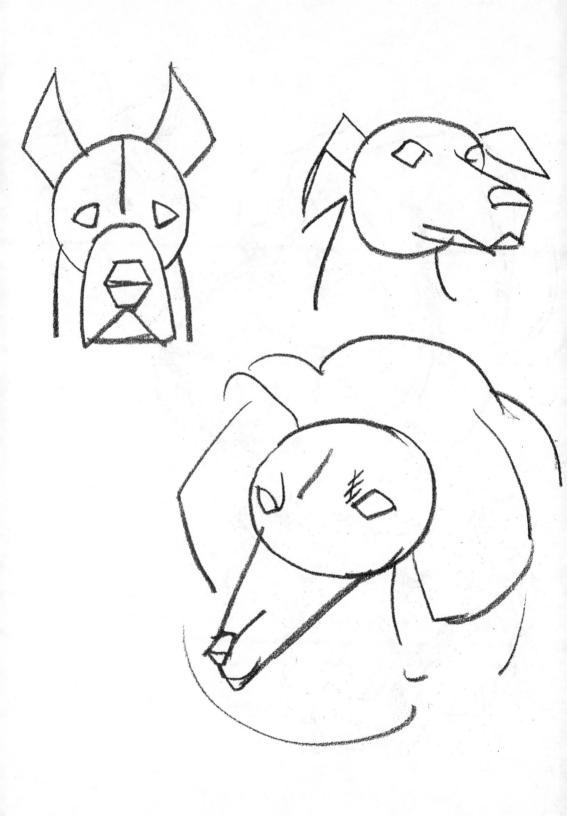

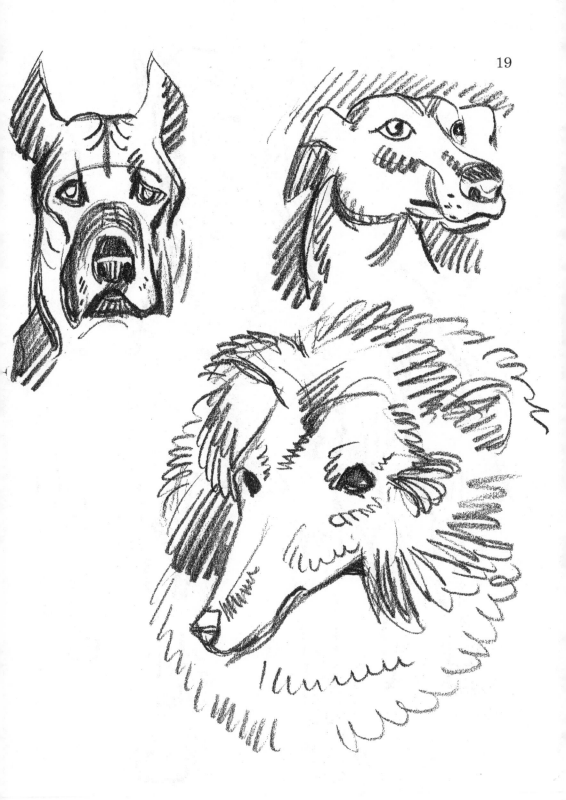

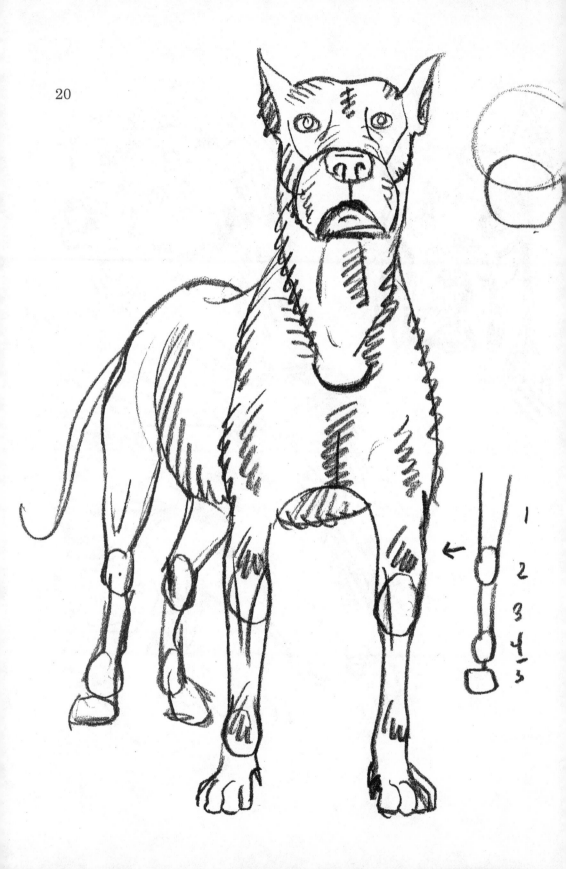

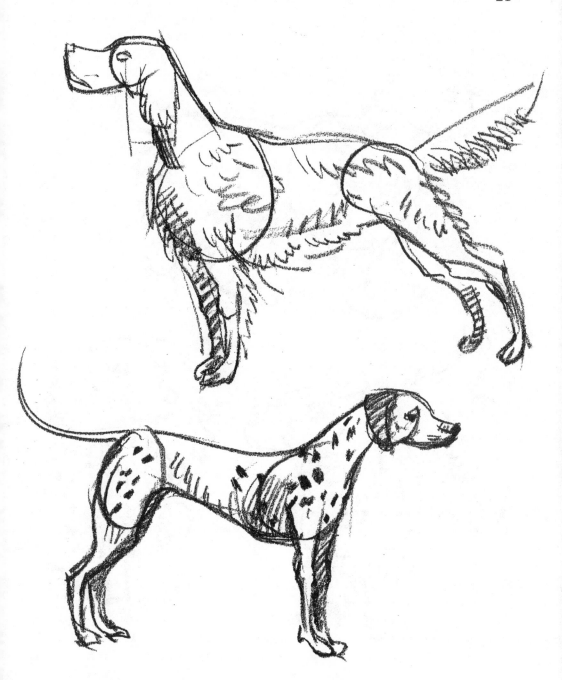

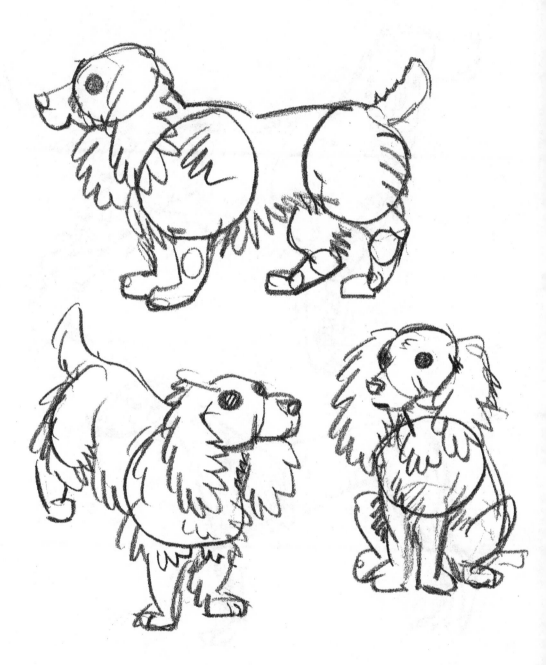

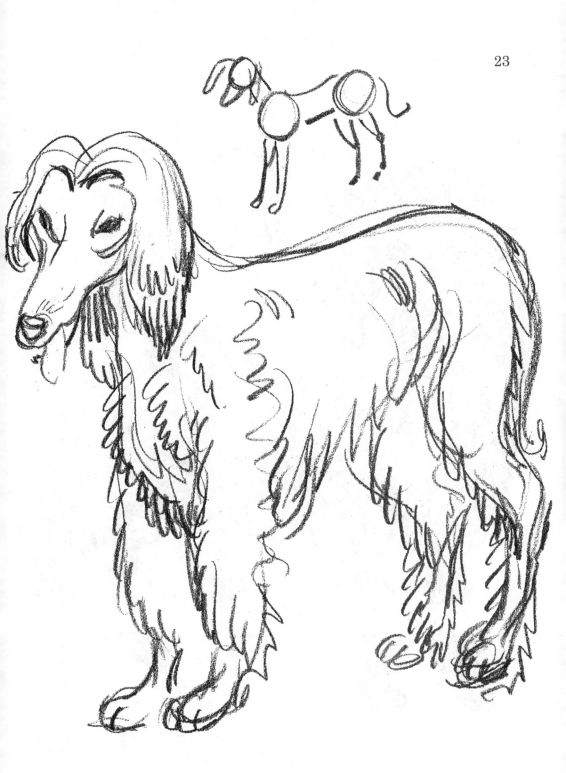

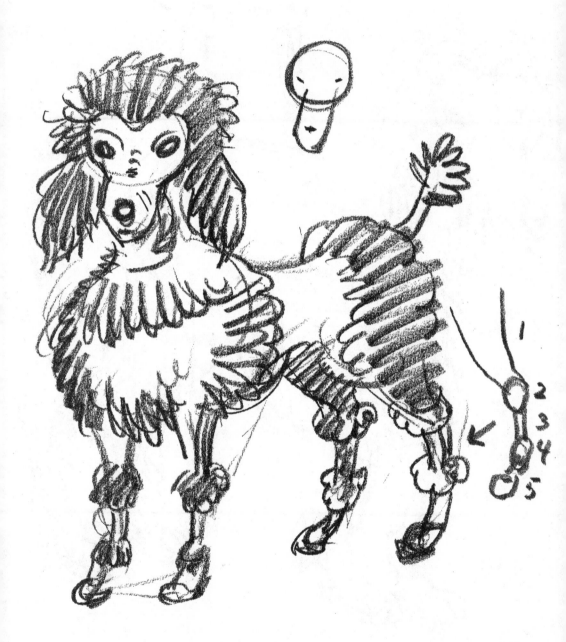

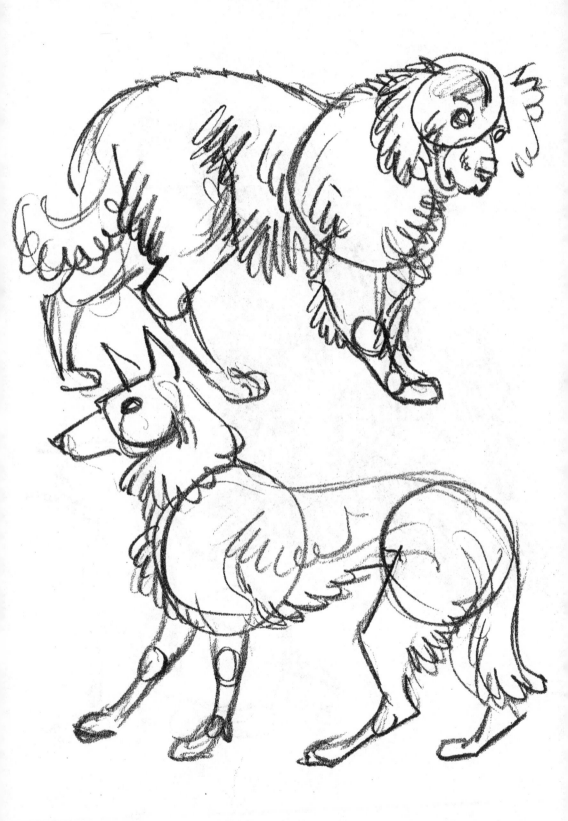

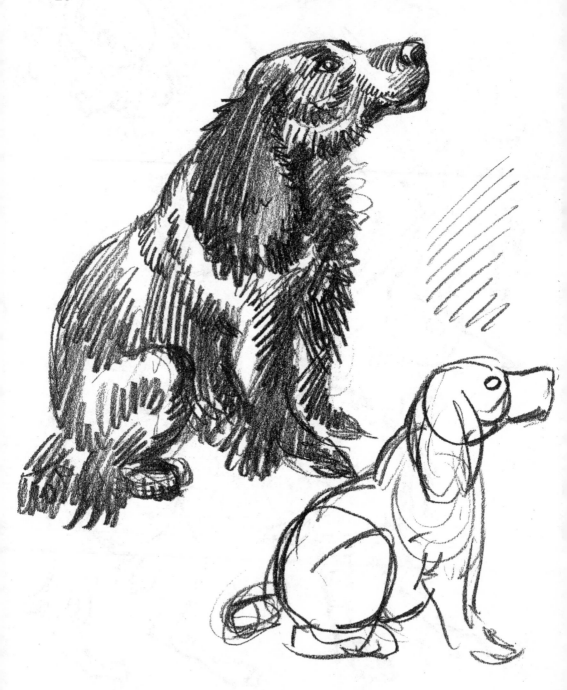

When you learned to write, you were taught to make your lines flow.
When you draw dogs in action, try to make your pencil lines flow with the action of the dog.

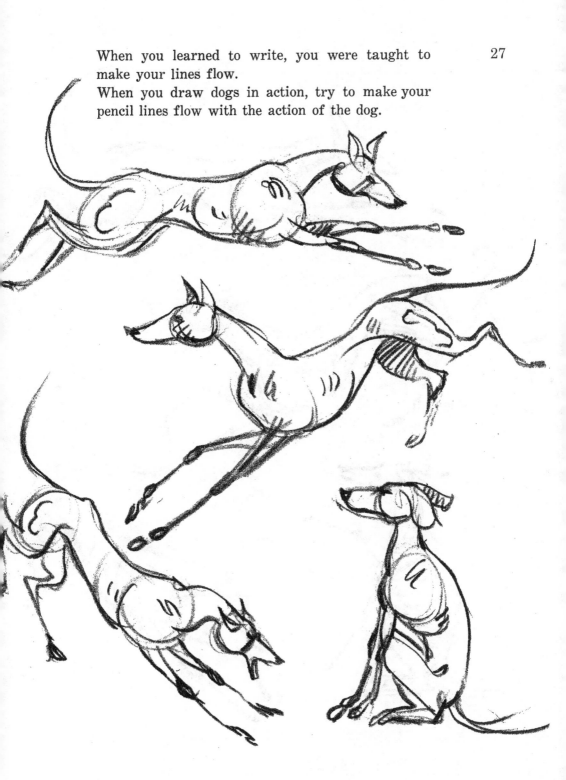

CATS

This part of our book is devoted to the house or alley cat. This little feline can be seen in many different places throughout every day of the year — on the street, on back fences, climbing trees, stalking mice or birds, fighting other cats, or running away from dogs.

We see cats curled up by the fire or stretched out in the sun, relaxed as no other animal can relax, completely and limply. Yet they are ready to leap into furious action in a split second if startled. Many of us have had them as pets at some time in our lives, yet few people ever learn to draw them well.

I think one reason is that a cat has many different moods which cause vast changes in his appearance. Unless you really understand these moods, it is not likely that you can show them in your drawings.

Let me explain the word "mood" and how it may be applied to drawing.

When you are very angry, you are in an "angry mood." Your attitude toward all things is affected by your mood. Your face, your posture, and even your blood flow is changed from what it was when you were calm or gay.

If you were to draw an angry boy or girl, you would remember how you felt when you were angry. You would understand that mood, and would put your understanding into your drawing of the angry boy or girl.

But you have never been a cat. You have never stalked a mouse or bird, never had to fight other cats, never had to sleep ready to leap into action at the sound of danger. These are moods of a cat which you have never felt yourself. You must come to understand them by watching carefully how cats behave. You will soon see how their moods change their appearance.

When a cat is on the prowl, stalking its food or its enemies, the lines of its body, the movement of its legs, the very shape of its eyes, change from the way they looked when it was contentedly lapping milk or resting in the sun.

If you can capture the various moods of cats, you will have won half the battle in drawing them. The other half of the battle is won by knowing some of the general details of the cat's body structure and its movements. Combine your understanding of moods and forms, and you will draw cats beautifully.

Use the two ovals and connecting barrel shape for the cat, as you did in drawing dogs.

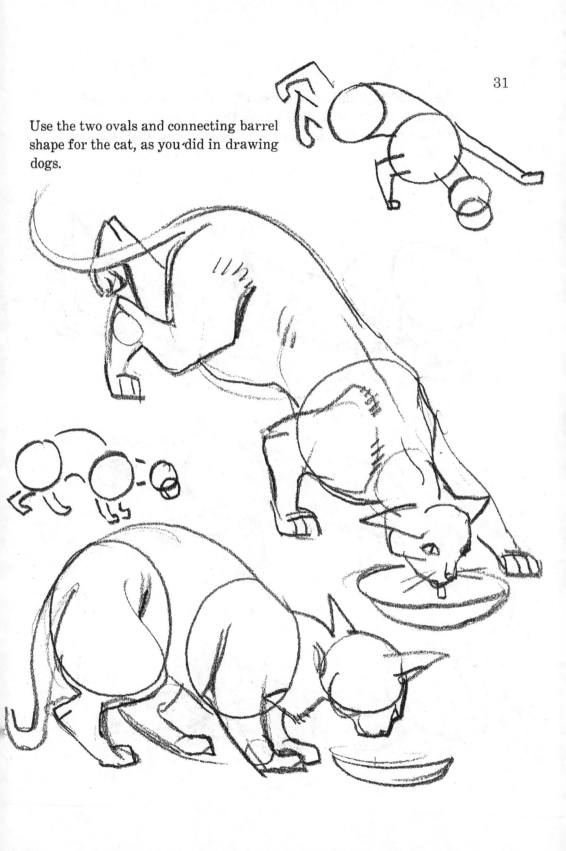

The thick fur and soft bones of the cat make its under structure harder to examine than that of the dog. Its movements are more fluid, and you must draw that flowing motion.

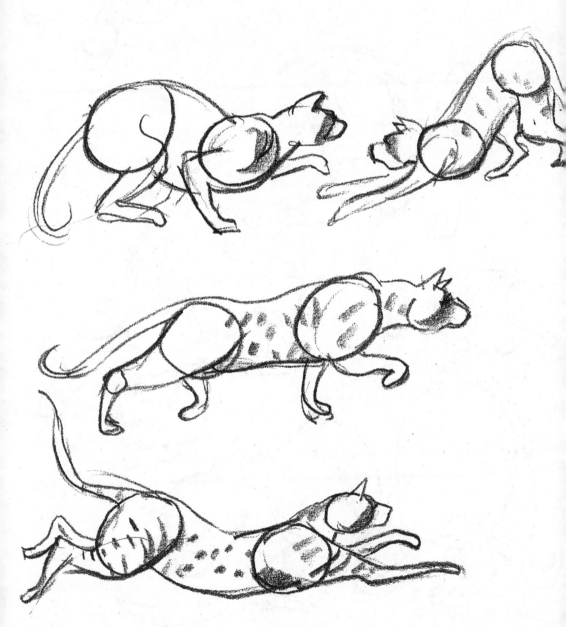

The legs and paws are soft and furry, but they are very strong. Study their general shape and practice their movements.

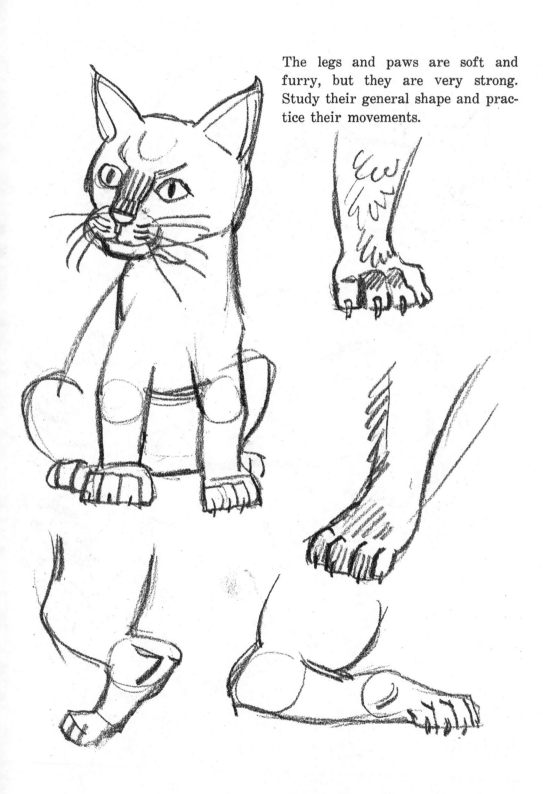

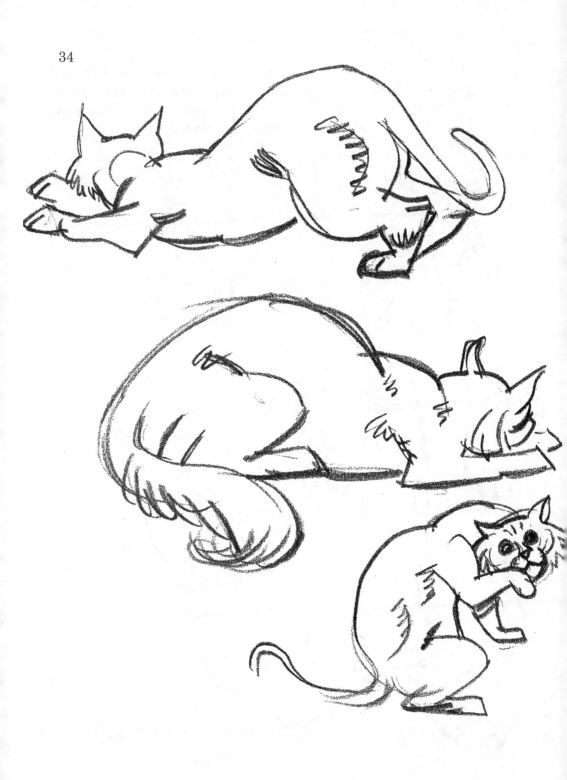

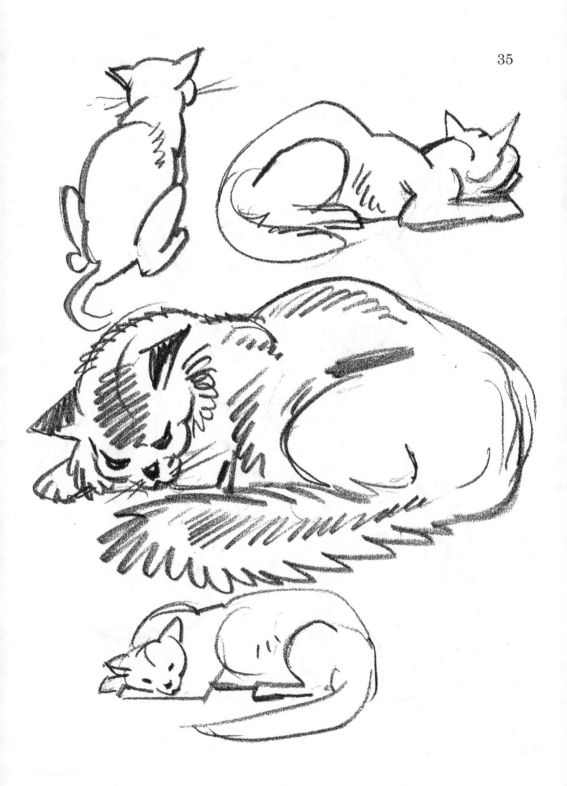

36 The cat's head can be made with two circles within which the almond shaped eyes, the blunt little nose and the pretty little mouth may be placed easily. The ears are little triangles sitting on top of the larger circle.

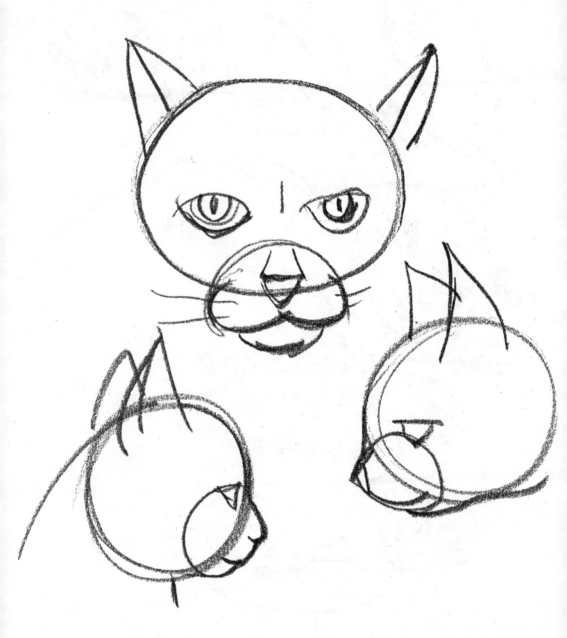

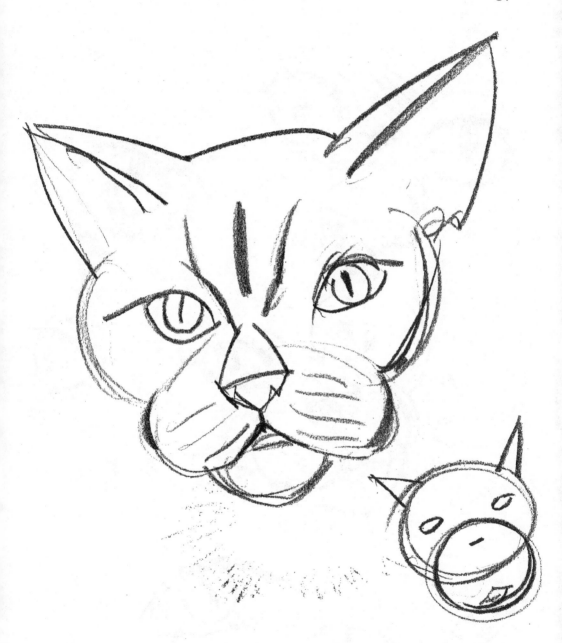

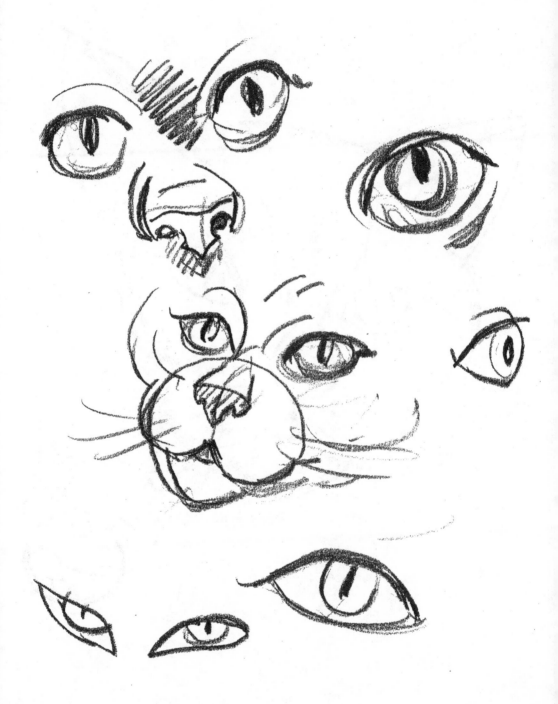

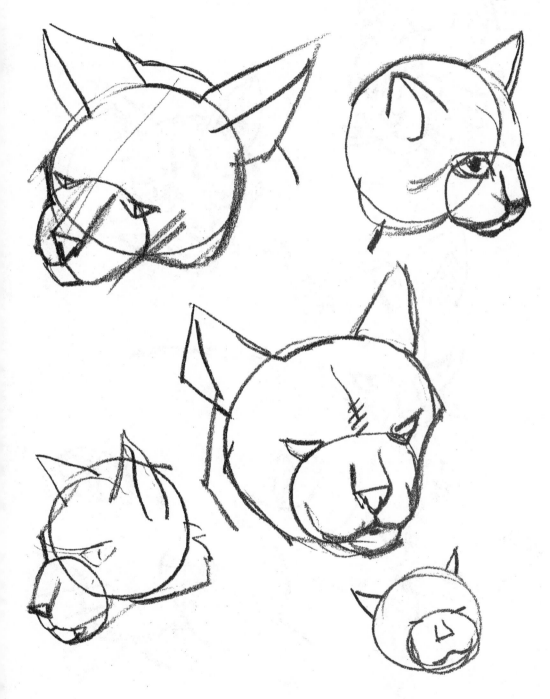

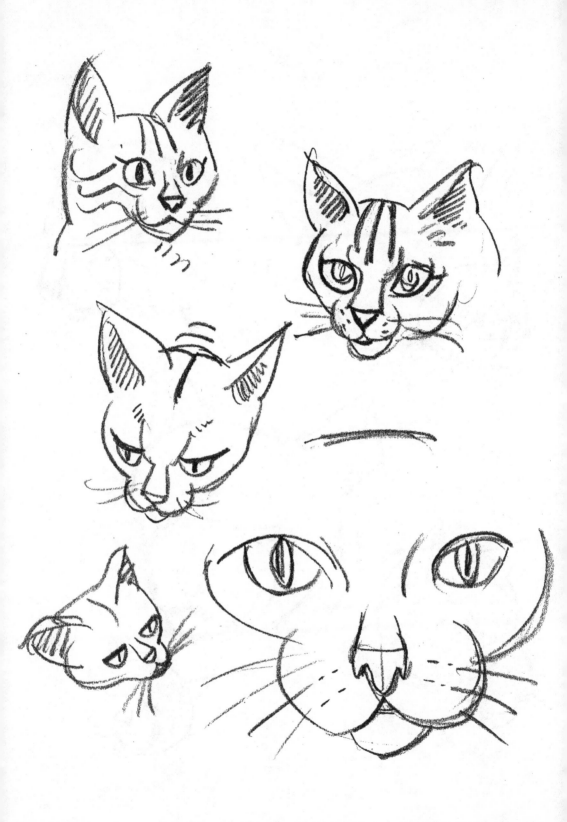

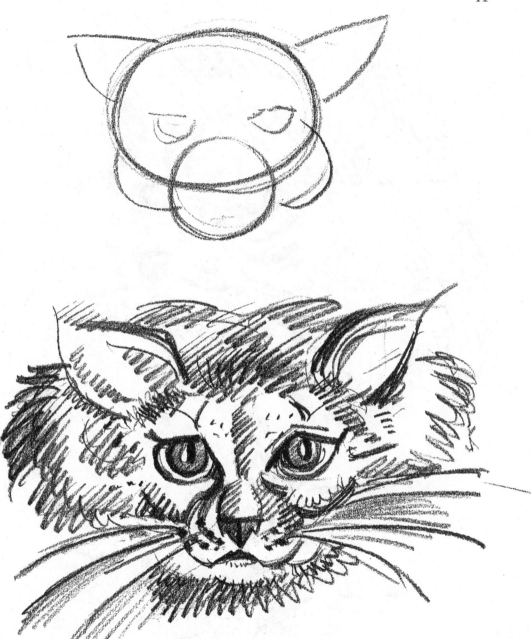

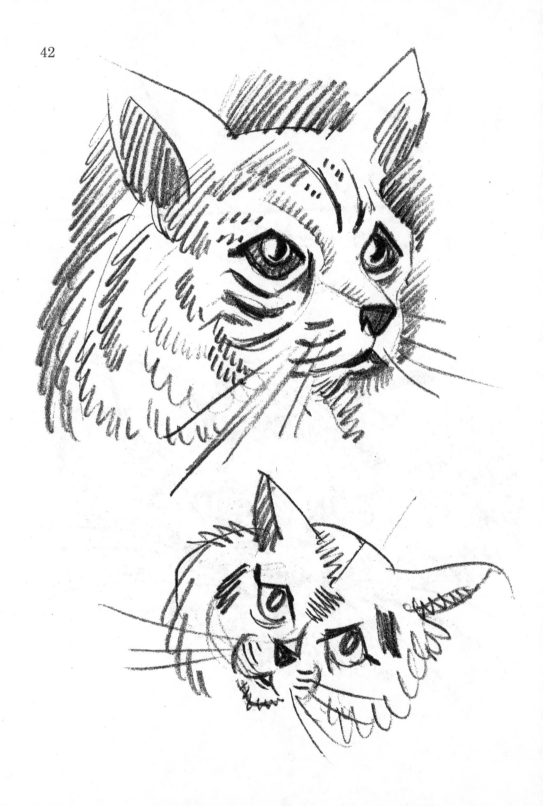

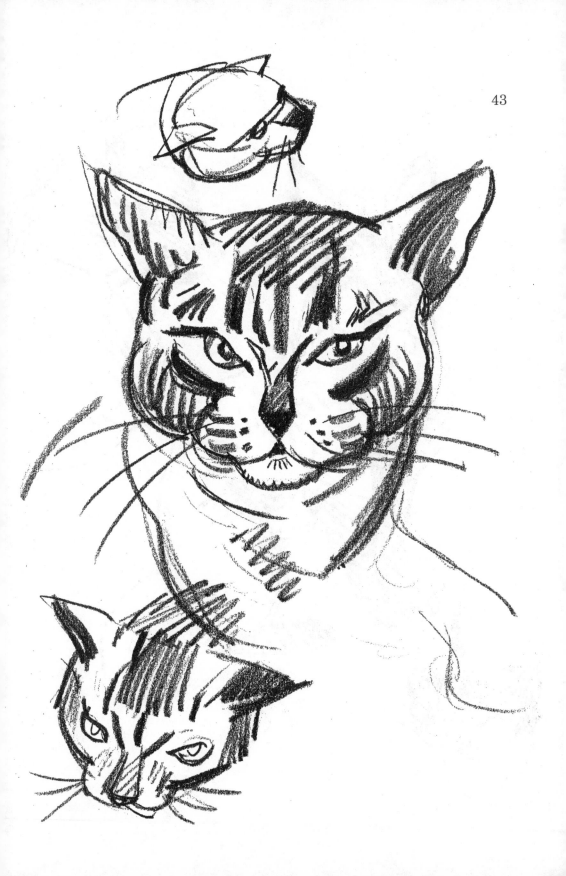

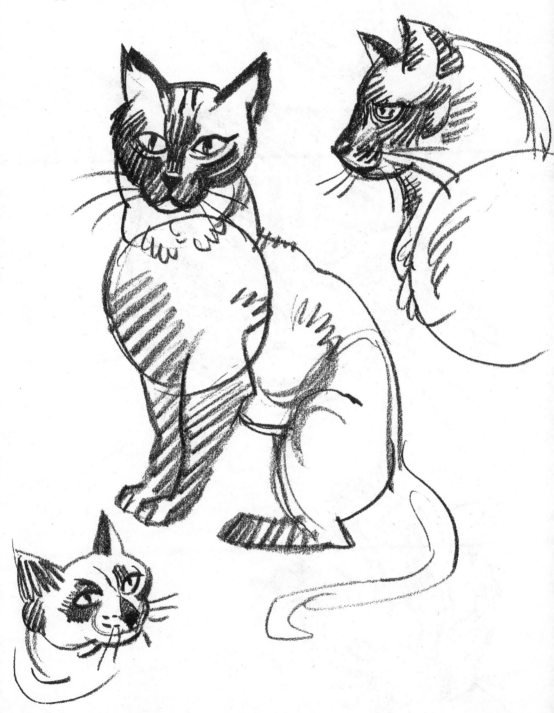

HORSES

From the artist's viewpoint, there are few things in Nature which can compare to the horse in beauty of design.

When an artist designs a picture, a piece of sculpture, or, if he is an industrial designer, a car or a speedboat, he knows what he wishes to "say." Then he "says" it with economy and good taste. Such a design is called "functional."

The horse is a beautiful example of Nature "saying" something with economy and the best of taste. We don't know the purpose of Nature when she created the horse, but for the use to which man has put the horse, it is beautifully designed. For speed, endurance, sport or toil, it is "functional," which means it "works."

Horses are streamlined. Their powerful muscles are long

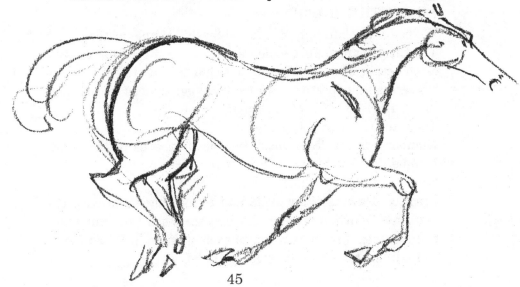

and do not bulge, except in the case of the heavy draught horse used for hard pulling.

The term "fat as a horse" is incorrect. Horses are rarely fat. The graceful neck, the fine head and the slender legs are usually in beautiful relation to the thickness of the torso.

To draw a horse, we need not study its entire anatomy — every bone, muscle and joint which makes up the wonderful living machine that is the horse. That would be as needless as learning the complex inner structure of the piano in order to play one.

We shall try to learn to "play" the horse. We must try to make our pencil perform that which a horse can perform. For that purpose we need to learn only how to make the general shape of a horse. But into that shape we must put a real understanding and love of the nature of the horse and what it does in life.

BEGIN THE HORSE

We begin the building of a horse by this simple method.
The three main shapes which are the base for all the complicated details of a horse's body are shown in this first plate.
These main shapes are two ovals or egg-shaped forms, and the "barrel" which is the stomach area.
They are numbered 1, 2 and 3.
Number 1 is the "container" for the chest area of the horse.
Number 2 is the hind quarters of the horse.
Number 3 is the stomach area.
Practice drawing these ovals and connecting them with the two lines which represent the barrel. When you can place them in their proper relation to each other in space and size, you will have a sound base for your horse.

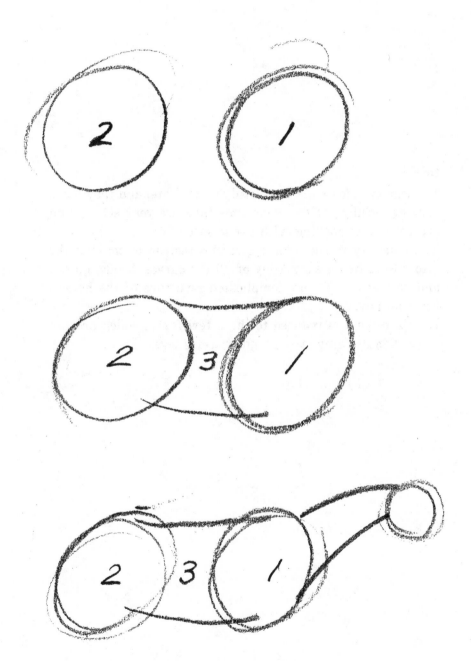

LEGS

The legs of a horse are beautiful and delicate, and they move very gracefully. At the same time they are very strong and are capable of moving with great speed.

You must try to show these qualities instead of making the effort to draw an exact copy of all the curves, bends, bumps and valleys in the very complicated structure of the horse's leg anatomy.

Here are the legs reduced to those few forms which are important in drawing strong and graceful legs.

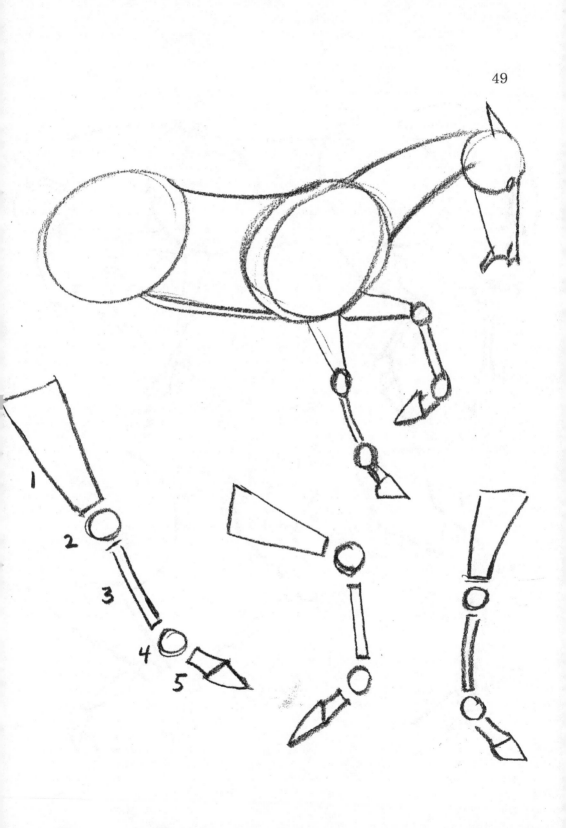

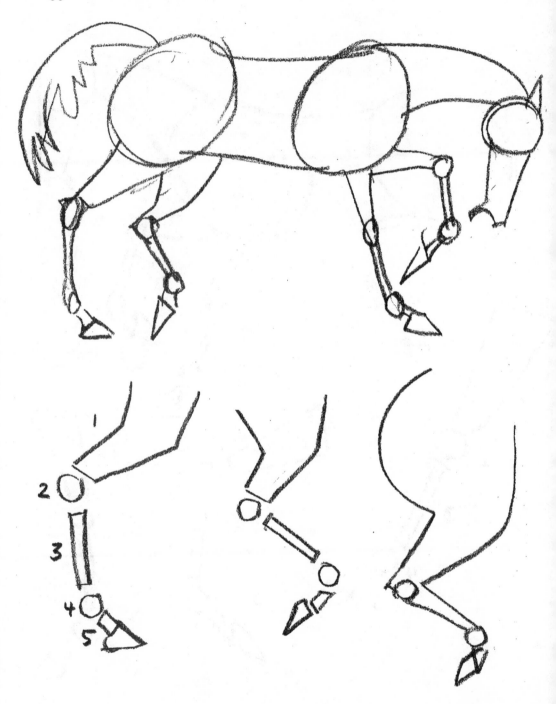

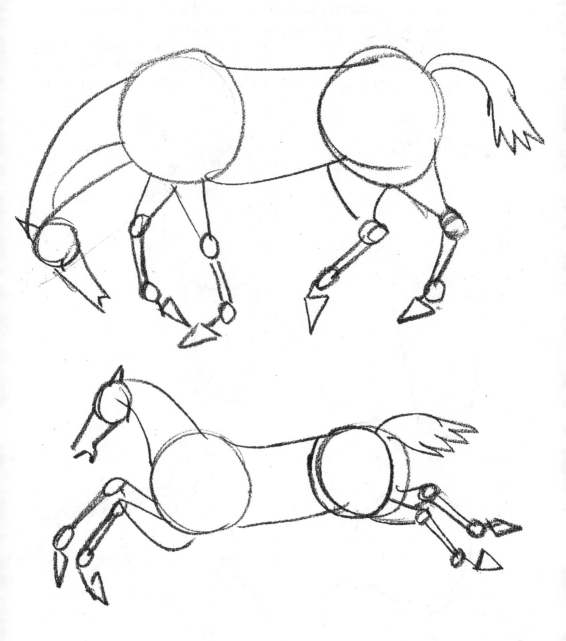

THE HEAD

Just as we reduced the very complex leg of the horse to a few simple forms, we now study the horse's head.

A circle forms the upper part of the head and an oblong the lower part. The oblong is wider at the point where it joins the circle, and it narrows as it reaches the nose and mouth.

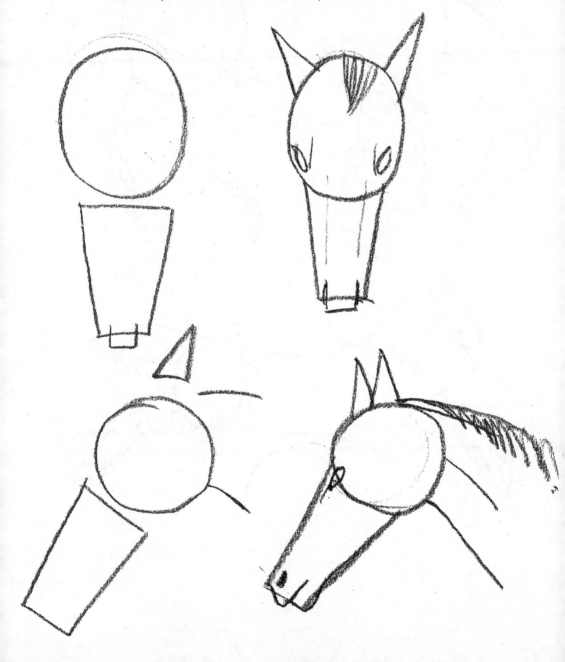

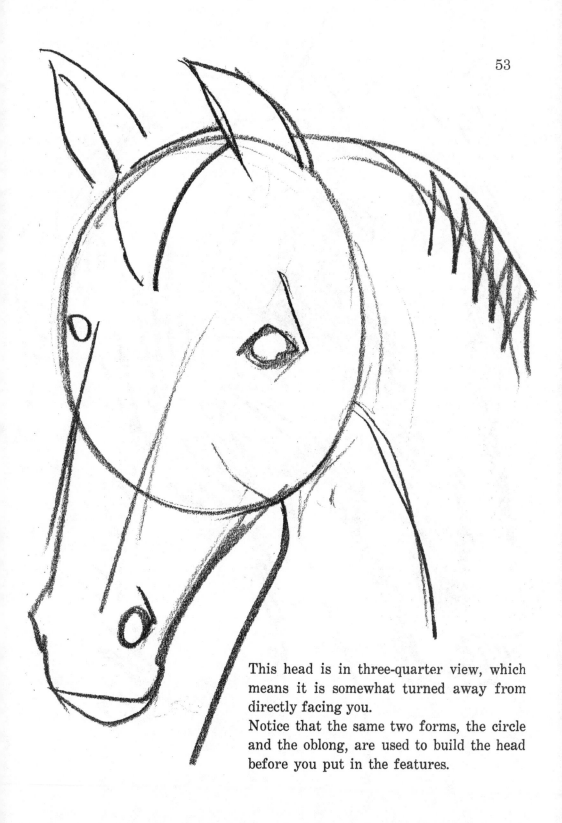

This head is in three-quarter view, which means it is somewhat turned away from directly facing you.

Notice that the same two forms, the circle and the oblong, are used to build the head before you put in the features.

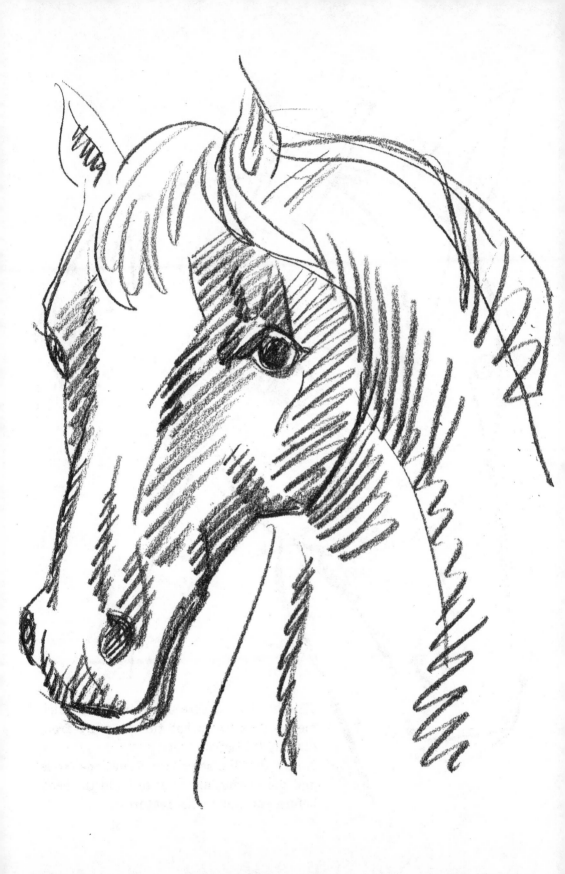

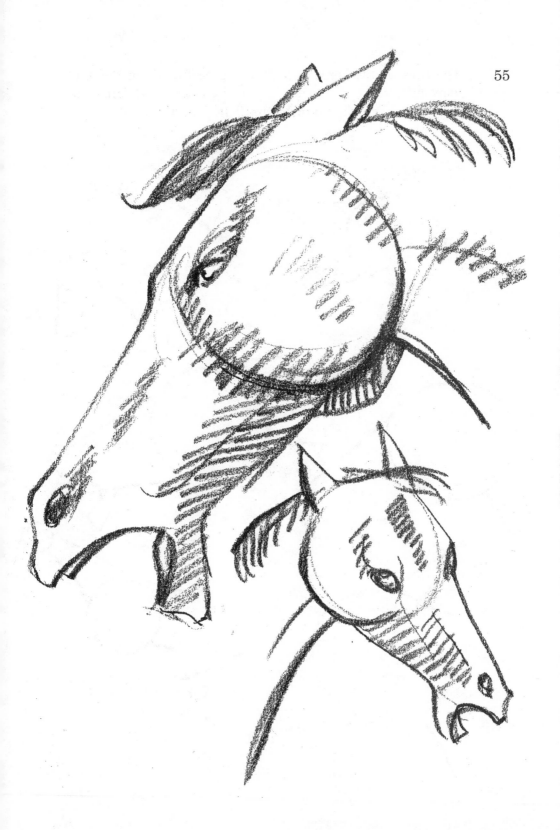

The neck of the horse is long and graceful. From the side view or profile, it is wide at the base where it joins the body and it grows narrower until it joins the head.

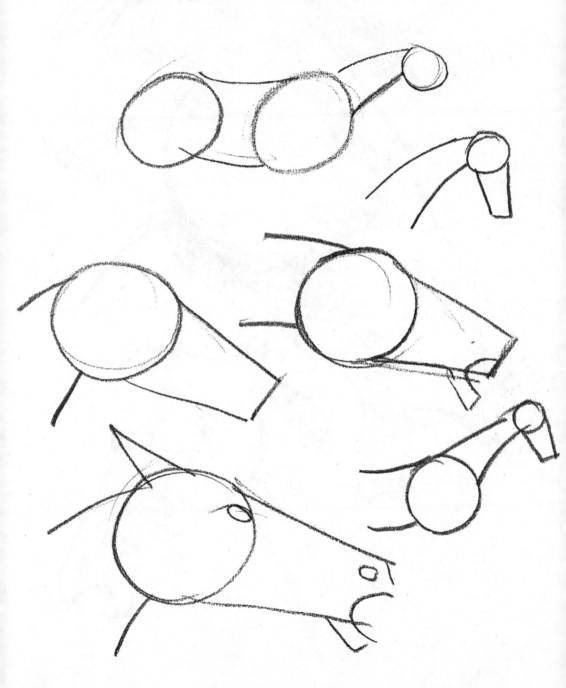

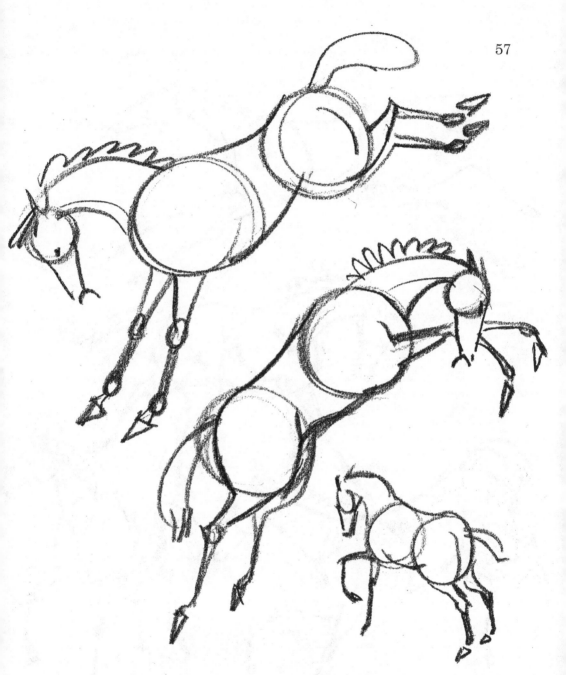

Practice using the circles, and the other simple forms into which we have divided the horse, in different actions and positions. If you keep them very simple, you soon will be able to draw horses moving and turning in every way.

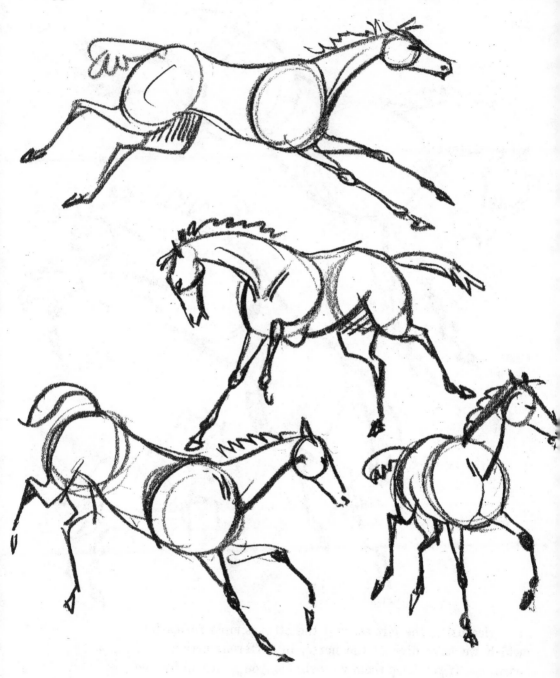

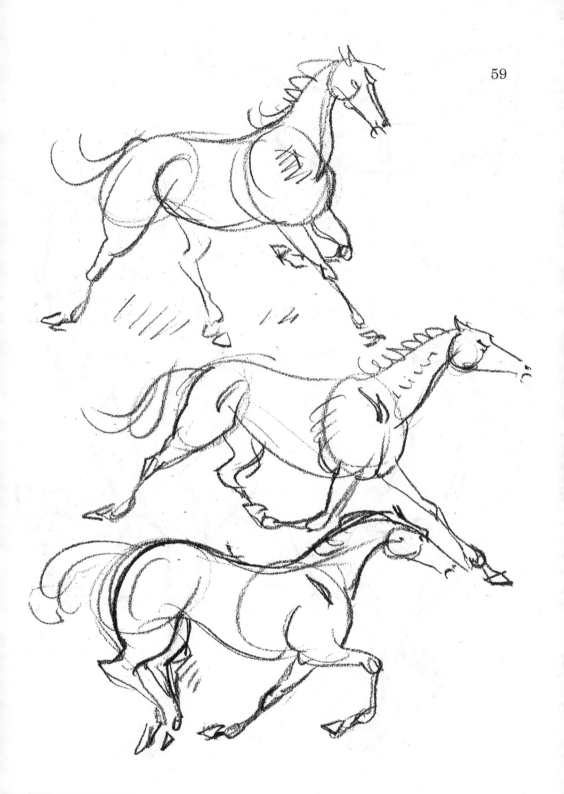

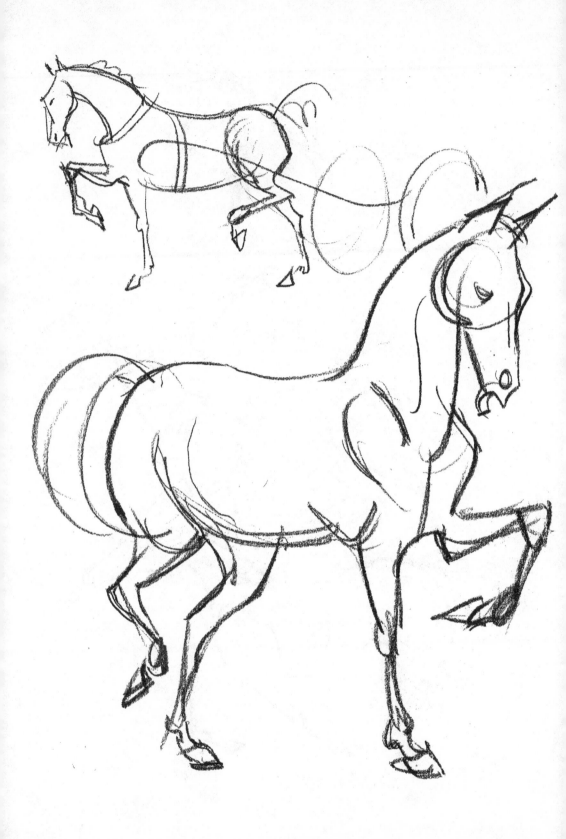

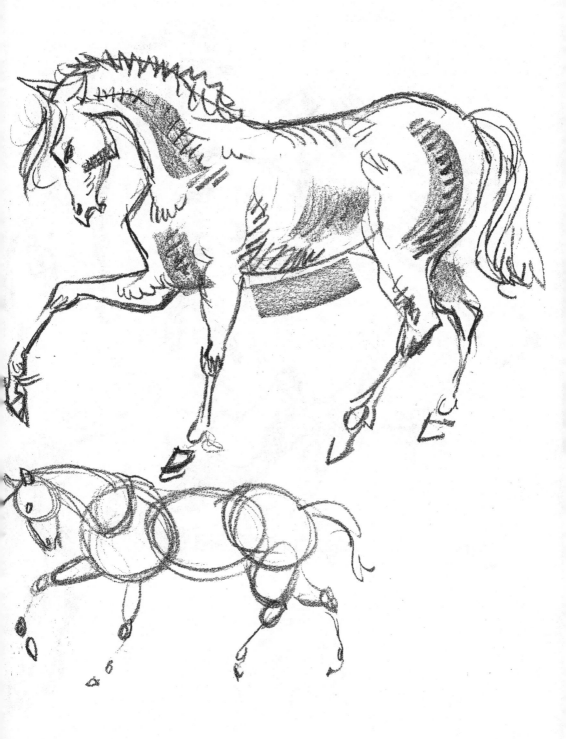

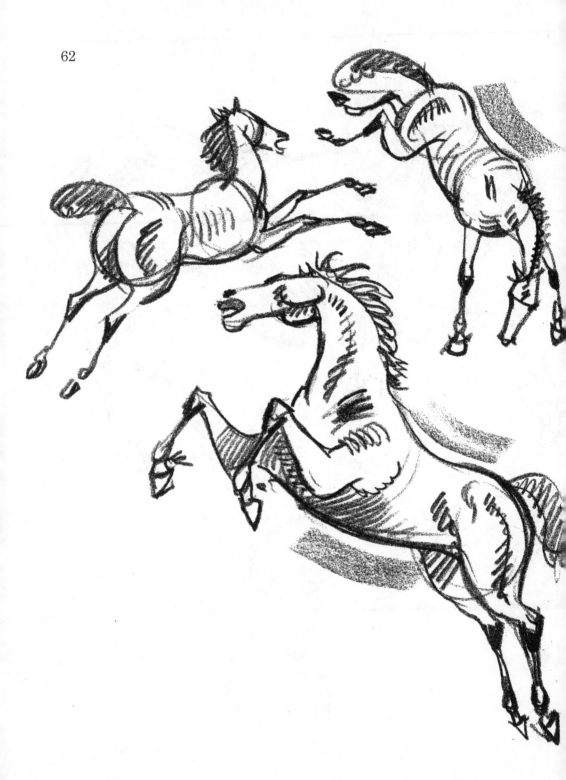

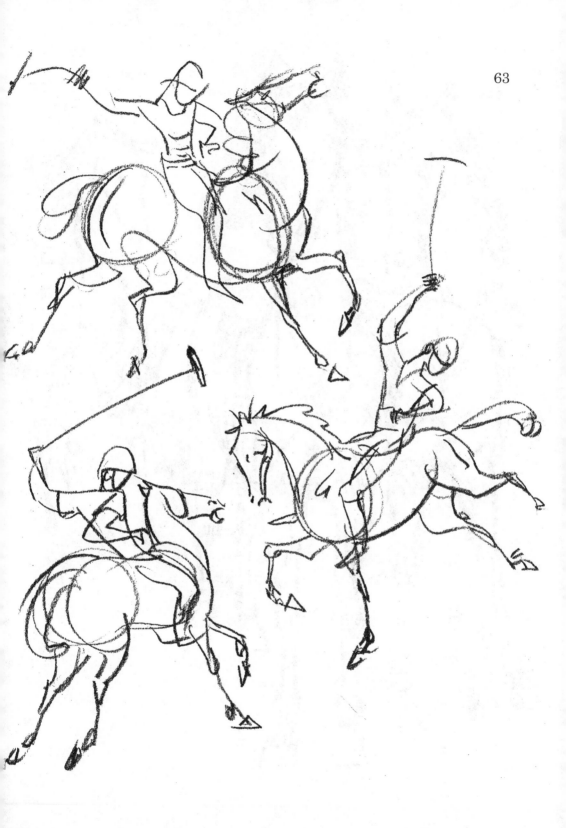

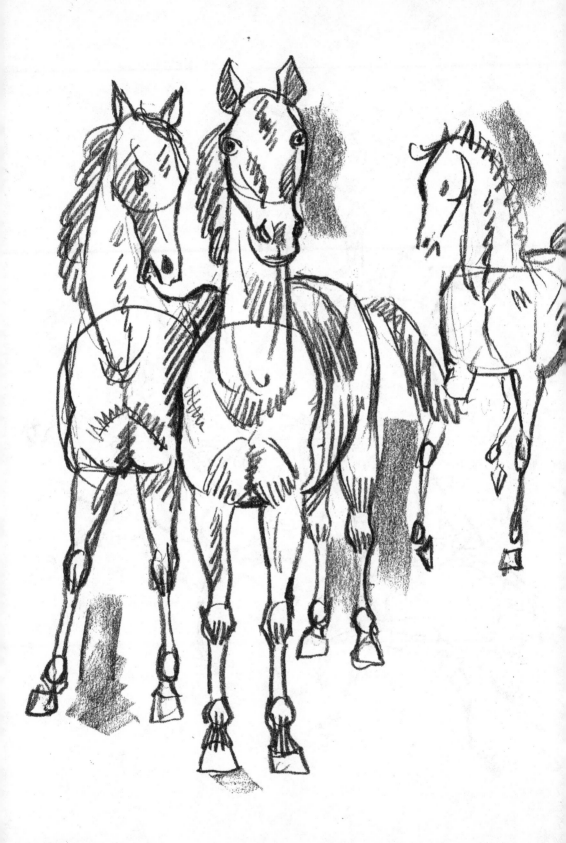